This is
Gauguin

Published in 2014 by
Laurence King Publishing
361–373 City Road
London EC1V 1LR
United Kingdom
T +44 20 7841 6900
F +44 20 7841 6910
enquiries@laurenceking.com
www.laurenceking.com

A catalogue record for this book is available
from the British Library.

ISBN: 978 1 78067 189 5

Series editor: Catherine Ingram

Printed in China

This is
Gauguin

GEORGE RODDAM
Illustrations by SŁAWA HARASYMOWICZ

LAURENCE KING PUBLISHING

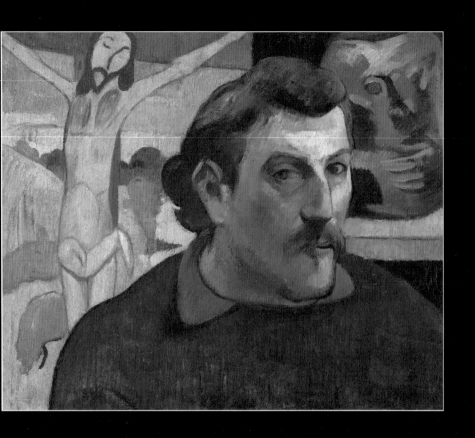

Portrait of the Artist with the Yellow Christ
Paul Gauguin, 1890–91

For Gauguin, an artist was a visionary, one who could see beneath the appearance of things to divine the deeper mysteries of life. In an 1890–91 self-portrait he shows himself staring out intently, his dark eyes piercing us as though gazing into our souls. Behind him he positioned two of his own works to tell us how he thought of himself.

On the left, *Yellow Christ* alludes to Gauguin's view of himself both as a martyr – he would spend most of his life fighting against those who did not understand his art – and as an artist possessed of an almost divine creative power. On the right, we see a glazed stoneware pot bearing a crude image of the artist's own face. In a letter to his friend Émile Bernard in 1890, Gauguin had described the pot as being 'scorched in the ovens of hell', as if 'glimpsed by Dante on his tour of the Inferno'. Gauguin would spend much of his life searching for an earthly paradise, but the pot makes clear that the artist, as an inspired visionary, must bear witness both to the joys of existence and to its sorrows.

A tempestuous birth

Eugène Henri Paul Gauguin was born in Paris on 7 June 1848. In a portent of the struggles that would plague him throughout his life, the streets outside the family home would soon be filled with the sound of fighting as some 10,000 people were killed or injured in clashes between government troops and workers. France's political strife caused problems for Gauguin's family: his father Clovis, a radical journalist whose views made him suspect in the eyes of the government, had trouble finding work. Gauguin's mother Aline had an equally stormy past. She had seen her own father convicted of the attempted murder of her mother, the famous feminist campaigner Flora Tristan.

A distinguished family

Gauguin often boasted of his ancestors on his mother's side. He talked proudly of Tristan, taking delight in shocking his more conservative acquaintances with accounts of how she had travelled the country preaching socialism, equality for women and free love. Tristan's father had been a colonel in the Spanish viceroyalty of Peru, and Gauguin listed the viceroys of Peru and the aristocratic Borgias of Spain among his forebears. He also claimed that the blood of the Incas and of South Pacific islanders ran in his veins. He was fascinated by the idea that he was a mix of the European and the non-European, proudly proclaiming that 'I come from the Borgias of Aragon, but I'm also a savage'.

Childhood in Peru

When Gauguin was one year old, his family left France to live with their relatives in Peru. His father Clovis died of a heart attack on the voyage, and Gauguin blamed the ship's captain – 'a terrible fellow', he would later say.

Gauguin and his mother and sister were welcomed in the Peruvian capital, Lima, by the artist's wealthy great-great-uncle, Don Pio Tristan y Moscoso. An old man of 109 who had made his money from guano and saltpetre, he took delight in his young relatives. He provided them with a house, a black maid and a Chinese serving-boy.

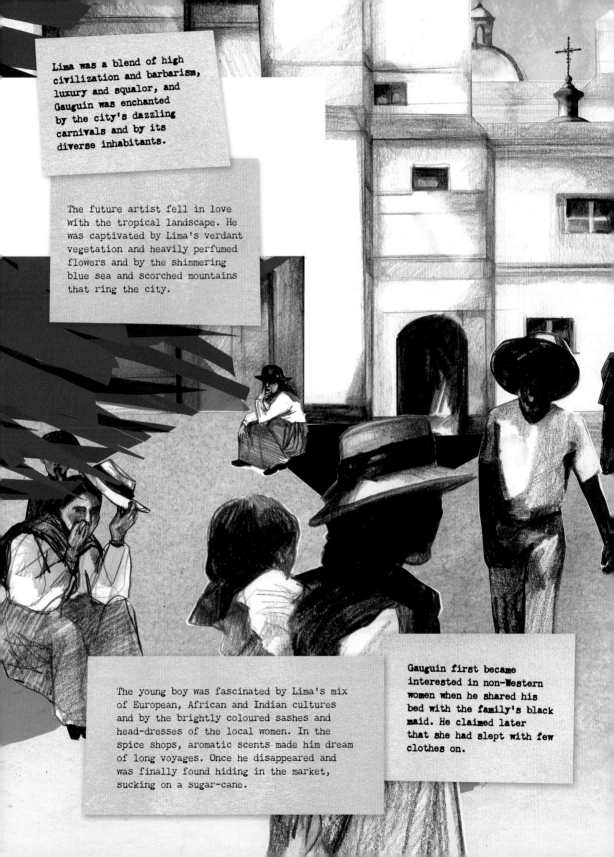

Lima was a blend of high civilization and barbarism, luxury and squalor, and Gauguin was enchanted by the city's dazzling carnivals and by its diverse inhabitants.

The future artist fell in love with the tropical landscape. He was captivated by Lima's verdant vegetation and heavily perfumed flowers and by the shimmering blue sea and scorched mountains that ring the city.

The young boy was fascinated by Lima's mix of European, African and Indian cultures and by the brightly coloured sashes and head-dresses of the local women. In the spice shops, aromatic scents made him dream of long voyages. Once he disappeared and was finally found hiding in the market, sucking on a sugar-cane.

Gauguin first became interested in non-Western women when he shared his bed with the family's black maid. He claimed later that she had slept with few clothes on.

The return to France

Gauguin's mother moved the family back to France in early 1855 when her father-in-law was on his deathbed. The legacy given to her by her Peruvian great-uncle, Don Pio, was quickly pocketed by other relatives, and the family was left desperately short of money. They lived in Orléans with Clovis's brother, Uncle Isidore, and Gauguin attended the local school. His exotic upbringing marked him out from the other boys and he spent much of his time alone, dreaming of the life he had left behind in Peru or using his pocket-knife to whittle dagger handles. Seeing these youthful carvings, a neighbour said, 'He'll be a great sculptor', a prediction that made a big impression on the young Gauguin. His teachers thought him gifted but strange. One of them noted, 'That boy will grow up either an idiot or a genius', a prophecy that Gauguin liked to repeat later in life.

Gauguin the wanderer

At 17, tiring of the constraints of his provincial life and remembering the joys of the tropics, Gauguin decided to go to sea. His mother begged him not to, perhaps remembering that his father had died on the voyage to Peru, but Gauguin had made up his mind. At the Channel port of Le Havre he became a pilot's apprentice on the *Luzitano*, which sailed between Le Havre and Rio de Janeiro. Gauguin stayed in the navy for almost six years, including three years of military service. He sailed all over the world, visiting ports from South America and the Caribbean to India and the Arctic. He most liked sailing in the southern oceans, where his memories of the warmth and rich colours of Peru were reawakened. He believed that life in the tropics was more in keeping with the needs and desires of human beings. He read the work of the philosopher Jean-Jacques Rousseau, who argued that the so-called civilization of the West was in fact marred by decay, with people divided from each other by jealousies over private property and sexual monogamy. Like Rousseau, Gauguin believed that in less-developed parts of the world people lived as noble savages, freely sharing food and love. Gauguin dreamed that one day he might be able to live in this way.

A respectable career

Gauguin's mother died while he was still at sea; he returned too late to attend her funeral. When he left the navy he lived near Paris with Gustave Arosa, a friend of the family. Arosa had an extensive art collection, and Gauguin became interested in modern painting while looking at the works by Gustave Courbet,

Eugène Delacroix and Honoré Daumier that adorned Arosa's house. Arosa used his contacts to get Gauguin a job at Bertin, a stock exchange broker at the Paris Bourse. There Gauguin enjoyed a successful but short-lived career. It was during his time at Bertin that he got to know Mette Gad, a young Danish woman from a respectable bourgeois family in Copenhagen who was in Paris to accompany her friend, Marie Heegaard, the daughter of a wealthy Danish industrialist. Mette was drawn to Gauguin's piercing dark eyes and was impressed by the stories he told of his mother's family and of his time in the navy. She thought that, with his job on the stock exchange, Gauguin would make a reliable and respectable husband. They wed in 1873 and Mette soon gave birth to the first of their five children. Of these, his daughter Aline would become Gauguin's favourite.

The solace of art

Mette had been wrong to see Gauguin as a safe bet. Even when
they married he was beginning to find the life of a broker stifling.
Increasingly, he came to see art as an escape from his humdrum
existence. In 1872 he had become friends with a fellow employee
at Bertin, Émile Schuffenecker, who aspired to be an artist.
Together they visited the Louvre and the Palais du Luxembourg,
where the French state's collection of modern art was exhibited.
Gauguin began to spend most of his free time with his artist
friends, leaving Mette on her own with the children. Much to her
dismay, her brother-in-law, the Norwegian painter Fritz Thaulow,
encouraged Gauguin to pursue an artistic career.

Impressionism

Gauguin was a quick learner, and his early work – for example,
a sculpted marble portrait bust of his wife whose expressionless
face suggests something of their cooling relationship – was
accomplished, if rather conventional. However, he soon became
interested in more advanced art, visiting the few Paris galleries
brave enough to show the work of the most cutting-edge painters.
He admired the work of Édouard Manet and the Impressionists
on display in the Durand-Ruel galleries and at the shop of Père
Tanguy, an independent-minded paint merchant who was the
first to buy the work of artists such as Paul Cézanne. He used his
salary from Bertin to buy their paintings and studied them to learn
their secrets. Soon he was spending his evenings in cafés such as
La Nouvelle Athènes, where the Impressionists met to discuss the
latest artistic developments. Sitting at the edge of the group, he
listened keenly to the pronouncements of his new colleagues: the
elegant Edgar Degas, always immaculately dressed in black; the
kindly Camille Pissarro, whose long beard was already turning
white; Claude Monet, often in his painter's beret; Auguste Renoir,
with his distinctive goatee; and the sullen and mostly silent
Cézanne. Cézanne, at the time a leading Impressionist, would go
on to become, like Gauguin, one of the great Post-Impressionists.

Artistic rivalries

In the later nineteenth century the Paris art world was riven by artistic rivalries. Competing avant-garde movements quarrelled incessantly and art critics promoted their own favourites. Most critics were hostile towards Impressionism, though by the time Gauguin was invited to exhibit with the Impressionists in 1880 the furore was beginning to die down. Monet and Renoir, the most famous and founder members of the group, refused to show with Gauguin and withdrew their work from the exhibition. He was not, in their view, a serious painter, but someone who had stolen their ideas. This anxiety about artists pilfering from each other was typical of the day. Being acknowledged as the inventor of a new painting technique was an important way of establishing one's reputation, and in a few years Gauguin himself would be worrying that younger artists were claiming his ideas as their own.

Monet and Renoir's criticism of Gauguin as merely a follower was not really fair. His paintings created at this time are full of life and energy. But it is true that he had not yet formed his own style. He himself joked about his reliance on the innovations of the Impressionists, writing a light-hearted letter to Pissarro about their colleague Cézanne: 'If Cézanne finds the recipe for compressing the exaggerated expression of his "sensations" into a single, unique procedure, please try to make him talk in his sleep . . . and come to Paris as soon as possible to tell us all about it.' The letter was written in jest: Gauguin did not really believe that painting consisted of secret formulae that could be stolen. But Cézanne took the threat seriously. When he heard of the letter he was not amused. Years later, when Gauguin travelled to Tahiti, Cézanne was still worried, complaining that Gauguin was now exploiting his 'sensations' in the South Seas.

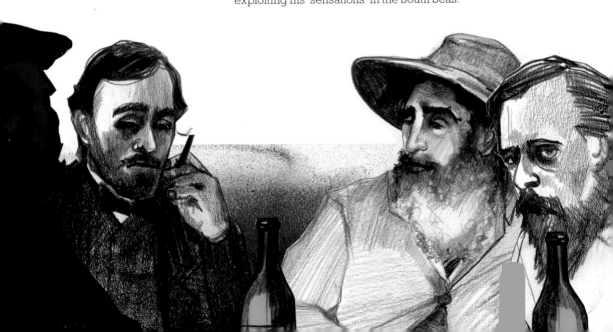

Nude Study

The Impressionists wanted to paint the life they saw around them rather than producing dull copies of the old masters. They were particularly interested in scenes of modern life, whether in Paris or in the surrounding countryside. Their goal was to paint exactly what their eye saw, recording the impression left on their retina by the colours of the world.

Gauguin's *Nude Study*, which was exhibited in the sixth Impressionist exhibition in 1881, shares this aim. Gauguin has not painted an idealized nude. Instead, he has for the most part recorded what he saw: an ordinary woman engaged in an everyday task in a modern interior. Some elements in the painting seem consciously 'artistic' – the lute on the wall, for example, which is probably Gauguin's invention. It suggests in a rather hackneyed way the bohemian life of an artist: such antiquated musical instruments were often seen in paintings by the previous generation of Romantic artists. But, apart from this slightly old-fashioned detail, Gauguin's painting is resolutely up to date. He has followed Impressionist procedures in closely observing how natural light illuminates the scene, recording the coloured shadows on the woman's body and the blue shadow cast by her knees on the white sheet. One of Impressionism's central tenets was that shadows are not black but coloured according to the quality of the light around them. Natural light, they argued, was slightly yellow because it came from the sun, and shadows therefore appeared to be tinged by blue, as blue is the complementary colour to yellow, directly opposite it on the colour wheel. As in the paintings of Monet and Renoir and the other Impressionists, the colours are bright, and Gauguin makes use of the Impressionist technique of quick brushstrokes to evoke the transitory play of light across the scene.

The woman in the painting is probably Justine, the Gauguin family's maid. Mette, who was increasingly unhappy about the time her husband was devoting to art, had forbidden her husband to employ professional models to pose for him. Perhaps she feared that he would stray. When she saw the painting she banished Justine from the family home.

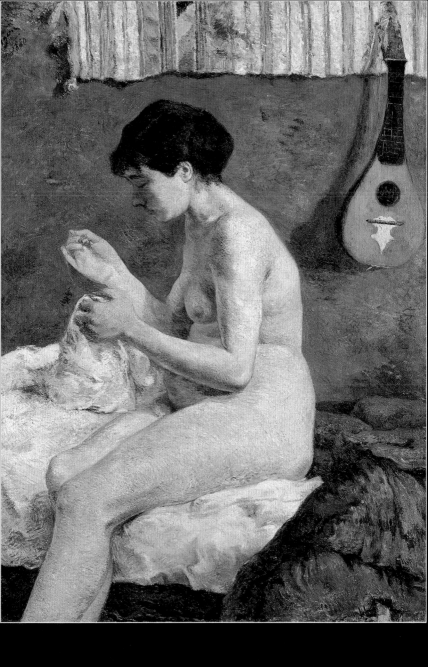

Nude Study (Woman Sewing)
Paul Gauguin, 1880

Oil on canvas
114 × 79.5 cm (45 × 31⅛ ɪn)
Ny Carlsberg Glyptotek, Copenhagen

A momentous decision

The *Nude Study* was noticed by influential critics, who praised its realistic depiction of flesh and its attention to the appearance of an ordinary, contemporary woman. Encouraged by this success, in 1883 Gauguin made a momentous decision. The Paris stock market had crashed and, though his job with Bertin was secure for the moment, he resolved to leave the stock exchange and to devote himself to art for a year. Mette was furious. She was about to give birth to their fifth child and thought her husband was selfishly forgetting his responsibilities.

Life as an artist

Gauguin revelled in the feeling of liberation that came from giving up his financial career. He continued to experiment with Impressionism, devoting himself to painting landscapes *en plein air*, or outdoors, under the guidance of Pissarro. Life as an artist was not always easy, however. Gauguin found no buyers for his work, and Paris was an expensive place to live. When Pissarro moved to the city of Rouen in Normandy in search of new subjects for his painting, Gauguin followed. He was able to live more cheaply: rents in Rouen were much lower than in Paris. He also hoped that the Rouen public, not having seen much modern art, might be more impressed by his work than the Parisian critics had been. It was a forlorn hope. The provincial taste of the citizens of Rouen, famously mocked in Gustave Flaubert's novel *Madame Bovary*, made them ill-disposed towards any kind of artistic innovation, and Impressionism in particular was too modern for most buyers. Unable to sell his work, Gauguin began to run out of money and, with his tail between his legs, went to live in Copenhagen with Mette.

The stay in Copenhagen was a disaster. Gauguin and Mette squabbled constantly about money and about his unquenched desire to be an artist. Under pressure, Gauguin tried his hand at other jobs. He worked as a tarpaulin salesman, hoping that this might be the answer to their financial problems. He even planned to expand the business into an international concern. But he was no better at selling tarpaulin than he was at selling canvases, and these plans came to nothing.

Gauguin's relationship with Mette's family was painfully strained. In a letter to Émile Schuffenecker he complained: 'To the family I am of course the monster who never earns a penny. And that, in the present age, is the standard by which one is judged!' Living with her relatives put an unbearable strain on their marriage.

Gauguin hoped that the other artist in the family, Fritz Thaulow, would help him by introducing him to potential patrons. Thaulow, however, was a more conventional painter and was unwilling to defend Gauguin's Impressionist works. As for buyers, the Danes were even less inclined to purchase a Gauguin than were the residents of Paris and Rouen.

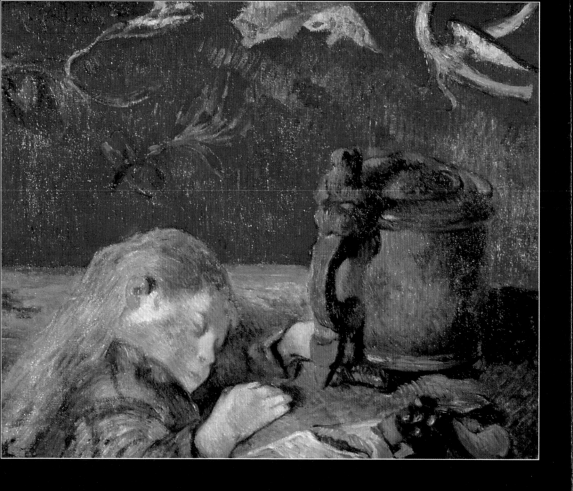

Sleeping Child (Clovis Asleep)
Paul Gauguin, 1884

Oil on canvas
46 × 55.5 cm (18⅛ × 21⅞ in)
Josefowitz Collection, Lausanne

Sleeping Child

Despite the difficulties in his personal life and the lack of support for his painting, Gauguin continued to develop as an artist. In 1884 he painted an image of his young son Clovis asleep. On one level the painting is an intimate portrait of his child just as he might have appeared, and the broken touches of colour on his face and hand continue the Impressionist technique of showing how light plays across the surface of the body. But the painting also shows how Gauguin was beginning to move beyond the tenets of Impressionism. The disjunctive scale of the Norwegian tankard – shown about three times larger in relation to Clovis than it was in reality – lends the painting a mysterious air, as though what we are looking at here is not the real world but a dream. The intensity of the colours – the rich blue of the wallpaper and the powerful red highlights on the tankard – add to the feeling that this is not an image of mundane reality. With its strangely hybrid creatures – part fish, part bird – the wallpaper might be either sky or sea, an indeterminate space that appears as a projection of Clovis's dreams. As viewers we are thrust into this strange world, seeming to share the young boy's unconscious vision. In the coming years Gauguin would become increasingly interested in the idea that painting should record not the surface appearance of things, as Impressionism had sought to do, but the innermost feelings of the artist and his subjects.

In the middle of 1885 Gauguin's relationship with Mette and her family reached breaking point. He returned to Paris, taking Clovis with him but leaving the other four children in Copenhagen. At first, things did not go well in Paris. Gauguin sold no paintings and he and Clovis were hungry and cold most of the time. But in May 1886 Gauguin participated in what was to be the last Impressionist exhibition. The positive reception given to his work raised his spirits and, with money in his pocket from a few sales at the exhibition, he departed for Brittany, leaving Clovis in a boarding-house in the suburbs of Paris.

Gauguin had heard about the coastal
town of Pont-Aven from artist friends.
It was cheap, quiet and unspoiled. On
the River Aven, which flows through the
town, numerous water wheels powered
the local mills, and outside the town
the famous beech wood called the Bois
d'Amour - the wood of love - was a
favourite spot for painters.

Brittany was less developed than
other parts of France, and many of
the locals still wore traditional
costumes, particularly on public
holidays. Pont-Aven was particularly
noted for the elaborate coiffes, or
head-dresses, of its women.

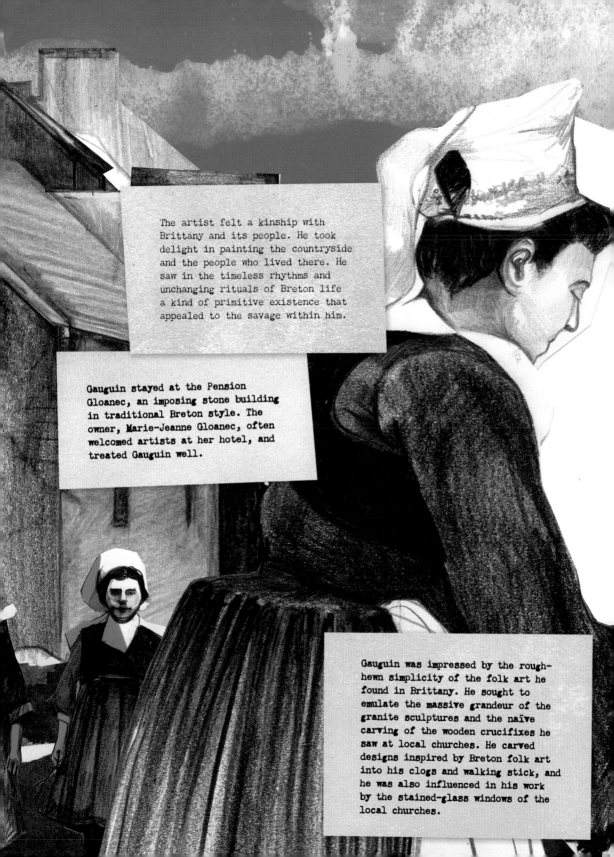

The artist felt a kinship with
Brittany and its people. He took
delight in painting the countryside
and the people who lived there. He
saw in the timeless rhythms and
unchanging rituals of Breton life
a kind of primitive existence that
appealed to the savage within him.

Gauguin stayed at the Pension
Gloanec, an imposing stone building
in traditional Breton style. The
owner, Marie-Jeanne Gloanec, often
welcomed artists at her hotel, and
treated Gauguin well.

Gauguin was impressed by the rough-
hewn simplicity of the folk art he
found in Brittany. He sought to
emulate the massive grandeur of the
granite sculptures and the naïve
carving of the wooden crucifixes he
saw at local churches. He carved
designs inspired by Breton folk art
into his clogs and walking stick, and
he was also influenced in his work
by the stained-glass windows of the
local churches.

Breton primitivism

Two Bathers shows one of Gauguin's favourite spots on the River Aven, a swimming-hole between the village and the Breton coast. Inspired by what he saw as the primitive nature of the area, Gauguin has transformed an everyday scene of bathing into a darkly resonant image. The central figure, shyly considering a dip into the water, is strangely androgynous, in keeping with Gauguin's view of Breton peasant women as asexual in their animal-like simplicity. The blocky contours of her body resemble the granite sculptures Gauguin admired in Brittany. The woman in the water is closely based on a painting of a nude bather by Degas. Degas's woman, who was shown washing in an iron tub in a Paris bedroom, was probably a prostitute. By transferring her to a verdant natural setting, Gauguin transforms Degas's image of a fallen woman into a symbol of human life in harmony with nature.

The lively brushwork, composed of individual strokes of paint, reflects the artist's lingering allegiance to Impressionism. Cézanne's influence is particularly strong, both in the repeated parallel strokes of paint and in the motif of the slender tree that cuts the image in two and whose location in space is hard to determine precisely. However, Gauguin departs from Impressionism in important ways. Instead of depicting exactly how the world appears to the eye, he shows instead his subjective response to Brittany. Gauguin wrote to his friend Schuffenecker of the feeling he sought to evoke with this type of painting: 'I love Brittany. I find there the savage, the primitive. When my clogs resound on the granite soil, I hear the muffled, dull powerful tone that I'm after in painting.' The muted tones and sombre emotion of the painting capture Gauguin's sense of the archaic quality of Breton culture. The landscape around the bathers seems untouched by human hands, as though we are thrust back towards the origins of humankind. Gauguin imagined that the peasants of Brittany, untainted by civilization, were a primitive people at one with nature. He almost always used Breton women to symbolize this, in keeping with a long-held European stereotype that women were closer to the rhythms of nature.

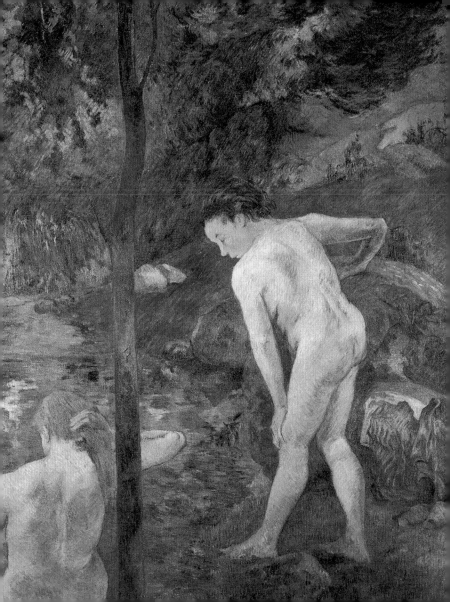

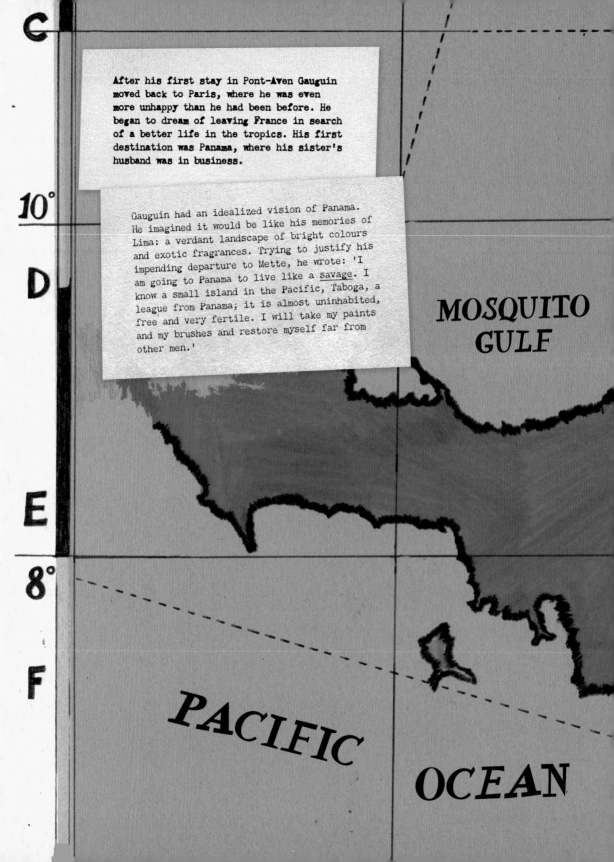

After his first stay in Pont-Aven Gauguin moved back to Paris, where he was even more unhappy than he had been before. He began to dream of leaving France in search of a better life in the tropics. His first destination was Panama, where his sister's husband was in business.

Gauguin had an idealized vision of Panama. He imagined it would be like his memories of Lima: a verdant landscape of bright colours and exotic fragrances. Trying to justify his impending departure to Mette, he wrote: 'I am going to Panama to live like a savage. I know a small island in the Pacific, Taboga, a league from Panama; it is almost uninhabited, free and very fertile. I will take my paints and my brushes and restore myself far from other men.'

C

10°

D

E

8°

F

MOSQUITO GULF

PACIFIC

OCEAN

CARIBBEAN SEA

MARTINIQUE

TABOGA

BAY
OF
PANAMA

When he arrived in Panama, Gauguin
found that the paradise he had imagined
was already lost, full of European
colonialists. Short of money, he worked as
a navvy digging the Panama Canal. Because
of the heat and mosquitoes the death rate
amongst labourers on the canal project
was high, and Gauguin feared he might die
there. Luckily his companion on the trip,
the painter Charles Laval, raised enough
money for them to escape to Martinique.

In Martinique Gauguin and Laval lived
in a hut on a sugar plantation.
From his window Gauguin could see
the sparkling blue waters of the
Caribbean and the lush groves of
oranges, lemons and mangoes that
lined the steep slopes of the island.

GULF

OF

PANAMA

Martinique Landscape

The intense colour and light of Martinique encouraged Gauguin to use brighter pigments in his paintings. The women he encountered – European, Chinese and African – were an endless source of inspiration as he tried to capture the exotic atmosphere of the island.

Gauguin's stay in Martinique ended badly when both he and his fellow traveller, Charles Laval, succumbed to malaria and dysentery but, before he became ill, he recorded his impressions of Martinique as an earthly paradise. In *Martinique Landscape (Comings and Goings)* he depicts the plantation where he lived. His hut is visible through the trees in the distance, its rusty iron roof surrounded by lush vegetation. Above it is the warm haze of a steamy Caribbean sky. In the foreground Gauguin has exaggerated the colours of nature – in particular the radiant red of the dirt path and the intense green of the grass – to symbolize the luxuriant warmth and fertility of the island. Tropical flowers and the relaxed poses of the female plantation workers convey Gauguin's vision of Martinique as a place of indolent pleasures. Chickens and a goat wander freely around the women, suggesting that life on the island is one in which people and nature exist in peaceful harmony.

One of the women reaches up to the tree to pluck fruit, echoing Gauguin's naïve belief that in the tropics food was freely available. In reality, the fruit on the trees was the property of the plantation owners, and the female workers laboured hard under difficult conditions. What Gauguin shows us are not the facts about Martinique but his dream of the island as Eden. But he subtly acknowledges that all was not perfect in Martinique: the woman reaching up to pluck the fruit reminds us of the biblical story of the Fall, suggesting that the island has lost its innocence with the arrival of colonialism.

In another image of Martinique, a lithograph entitled *The Grasshoppers and the Ants*, Gauguin again showed female workers in a plantation. The title of the print refers to the well-known fable by the seventeenth-century French writer Jean de La Fontaine. In the fable, a grasshopper passes the summer in idle play while an ant works hard. When winter arrives the grasshopper, now starving, asks the ant to share the food it has laboured to collect. The ant refuses. For La Fontaine, the meaning of the fable was that you should not waste your time in pursuit of idle pleasures. Gauguin inverted the meaning, suggesting that the ant was in the wrong and that a life of languid repose was in fact the ideal.

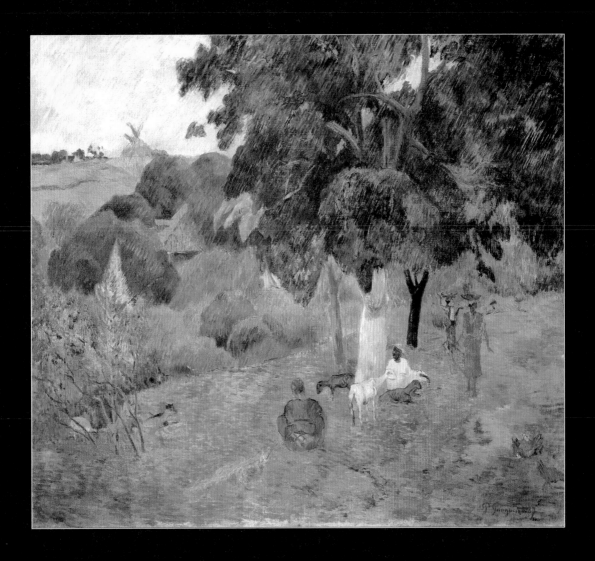

Martinique Landscape (Comings and Goings)
Paul Gauguin, 1887

Oil on canvas
72.5 × 92 cm (28½ × 36¼ in)
Museo Thyssen-Bornemisza, Madrid

New friends

After falling ill in Martinique, Gauguin had to earn his passage home by working as a sailor on a ship bound for France. He arrived back in Paris penniless but with a growing reputation among the avant garde. He would spend his evenings surrounded by a select group of admirers as they debated the latest artistic developments at their new haunt, the Café du Tambourin. The most prominent members of the group were the youthful Émile Bernard, whom Gauguin had first met in 1886 in Pont-Aven; Henri de Toulouse-Lautrec, diminutive of stature but with a gargantuan taste for absinthe and brothels that appealed to Gauguin; and, most importantly, Vincent van Gogh. Van Gogh used to sit at the edge of the circle of painters, remaining mostly silent but occasionally launching into a violent argument when somebody said something with which he disagreed. At first Gauguin was not sure what to think about the quarrelsome Dutchman, but he gradually recognized in him a kindred spirit: one who was willing to suffer for his art, and one who sought to record not the appearance of things but the passions and ideas that ruled over him.

Symbolism

Symbolism was a late-nineteenth-century artistic and literary movement. Reacting against what they saw as the rationalism and materialism of their contemporaries, Symbolist poets proclaimed the superiority of pure subjectivity over the realistic description of the natural world. Gauguin had already been pursuing similar goals in his art for a few years, and he and his friends soon became associated with Symbolist circles. Gauguin and van Gogh both rejected the conventions of Impressionism, arguing that the work of art should use colour, line and composition in non-naturalistic ways in order to express the feelings and thoughts of the painter. They wanted an art that would depict elements of the real world – it would not of course be wholly abstract – but that would organize and distort those elements in order to convey particular emotions and beliefs.

In an 1891 article, the art critic Albert Aurier gave the first published definition of Symbolism in painting, describing it as the subjective vision of an artist expressed through a simplified and non-naturalistic style. He hailed Gauguin as the leading practitioner of Symbolist painting.

Leader of a school

In 1888 Gauguin returned to Pont-Aven where he became the leader of a small band of painters, later known as the School of Pont-Aven. Other, more conventional, artists working in the village viewed the group with suspicion, jokingly labelling them 'plague victims' and christening the dining-room where they ate as a branch of Charenton, the notorious Parisian lunatic asylum. But Gauguin and his friends were not mad. They were exploring how the goals of Symbolism might be achieved in painting through the use of concentrated colour and simplified form. That summer Gauguin taught a young disciple, Paul Sérusier, a famous lesson. 'How do you see these trees?' he asked Sérusier. 'They are yellow. So, put in yellow. This shadow, rather blue: paint it with pure ultramarine. These red leaves? Put in vermilion.' Sérusier's painting, which shows the River Aven on the outskirts of Pont-Aven, became known as *The Talisman*. Back in Paris it was seen by many as a revelation. Younger artists saw it as the model of a new kind of painting combining observation of the world with personal feeling.

Paul Sérusier
The Talisman, 1888
Oil on wood.
27 × 21 cm (10⅝ × 8¼ in)
Musée d'Orsay, Paris.

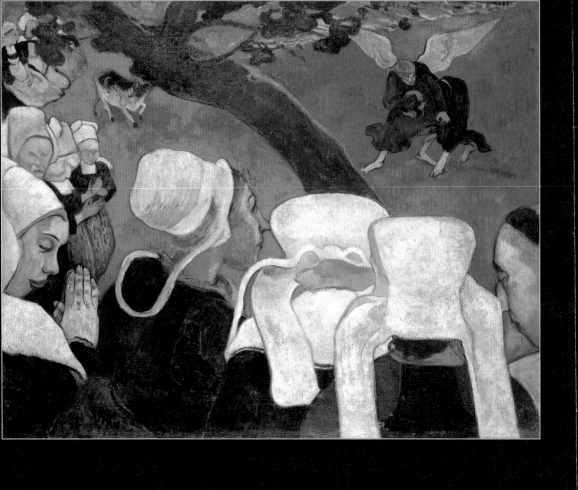

Vision after the Sermon

Vision after the Sermon depicts Breton peasant women experiencing an ecstatic spiritual vision after listening to a sermon in church. Gauguin shows us what the kneeling figures on the left, eyes closed and hands clasped in prayer, see in their mind's eye: the biblical story of Jacob wrestling with the Angel that the priest to the right has just recounted in his sermon. The non-natural colours, especially the bright red grass, and the odd scale of the wrestlers and of the cow, make clear that what we see here is not reality but a vision. The dark black outlines given to objects echo the appearance of the stained-glass windows that Gauguin had admired in local churches. The reference to church windows is particularly appropriate given the painting's theme.

Gauguin believed that, because the region had not been modernized, its inhabitants were more in touch with traditional rituals and archaic beliefs than were other French citizens. He held this to be particularly true of the local women. He saw their traditional head-dresses, the Breton *coiffes*, as a sign that they had stayed true to the old ways. In fact, the *coiffes* were only worn on public holidays, and increasingly were put on primarily to entertain the tourists who were beginning to arrive in great numbers in Brittany.

The simplified colours and the stylized contours of the women's head-dresses suggest that Gauguin shares in the vision, that he sees the world in the same way as these simple and pious peasants. This was Gauguin's way of showing that, like the Bretons, he was a primitive. Although he wanted to be like them, they rarely saw him as being one of them. They found it impossible to understand his art, which, despite his efforts, they found impossible to relate to their own folk art. Gauguin offered the painting to two local churches but not surprisingly both refused. Although he identified with Breton culture, the Bretons saw him as an outsider and his work as bizarre modern painting.

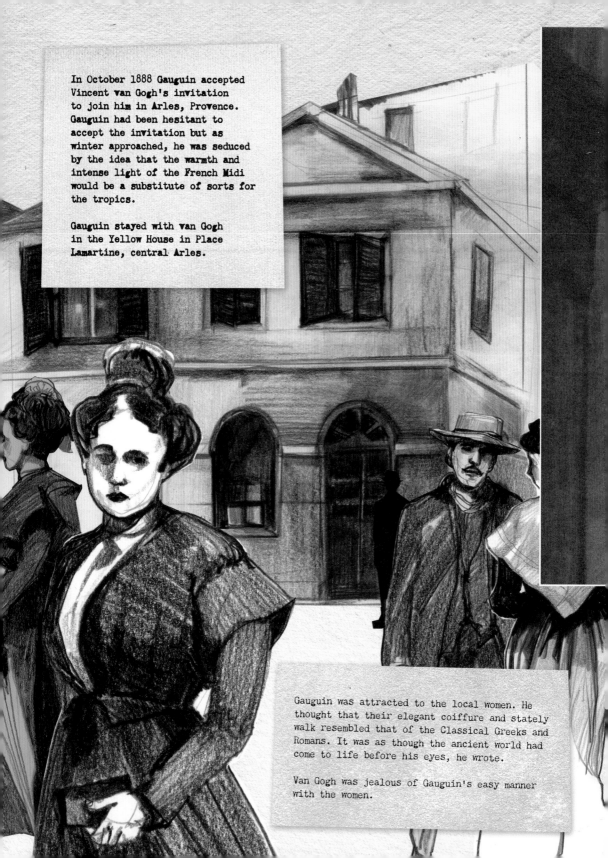

In October 1888 Gauguin accepted Vincent van Gogh's invitation to join him in Arles, Provence. Gauguin had been hesitant to accept the invitation but as winter approached, he was seduced by the idea that the warmth and intense light of the French Midi would be a substitute of sorts for the tropics.

Gauguin stayed with van Gogh in the Yellow House in Place Lamartine, central Arles.

Gauguin was attracted to the local women. He thought that their elegant coiffure and stately walk resembled that of the Classical Greeks and Romans. It was as though the ancient world had come to life before his eyes, he wrote.

Van Gogh was jealous of Gauguin's easy manner with the women.

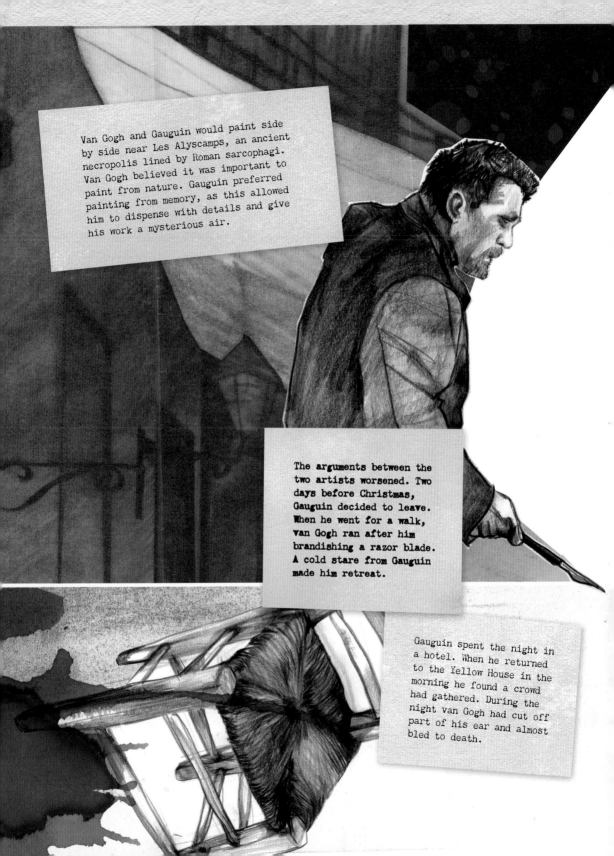

Van Gogh and Gauguin would paint side by side near Les Alyscamps, an ancient necropolis lined by Roman sarcophagi. Van Gogh believed it was important to paint from nature. Gauguin preferred painting from memory, as this allowed him to dispense with details and give his work a mysterious air.

The arguments between the two artists worsened. Two days before Christmas, Gauguin decided to leave. When he went for a walk, van Gogh ran after him brandishing a razor blade. A cold stare from Gauguin made him retreat.

Gauguin spent the night in a hotel. When he returned to the Yellow House in the morning he found a crowd had gathered. During the night van Gogh had cut off part of his ear and almost bled to death.

Van Gogh Painting Sunflowers

Gauguin learned a lot by working with van Gogh in Arles. He was particularly taken by van Gogh's love of blue and yellow and by his passionate discussion of the flat areas of pure bright colour found in Japanese prints. Gauguin made use of these ideas in *Van Gogh Painting Sunflowers*. Against a background dominated by the juxtaposition of sky blue and lemon yellow, he showed his Dutch colleague painting his favourite motif, the sunflowers that filled the fields around Arles during the summer months. Van Gogh gazes in rapt attention at the flowers as he presses his brush against the canvas he is painting. Gauguin meant the portrait as a sign of the two artists' friendship, but van Gogh was not happy with how he was shown. Perhaps because their relationship was already becoming tense, he viewed Gauguin's picture with suspicion. He wrote to their mutual friend Bernard: 'Yes, it's me all right, but me mad.'

Gauguin's Chair

Van Gogh also painted Gauguin's portrait, but his most telling image is of Gauguin's chair in the Yellow House. This is a portrait of his friend's imagined presence – the candle stands for the vitality of the painter – but it is also an image of absence. In his letters to his brother Theo, van Gogh spoke repeatedly of his fear that Gauguin would not stay long in Arles.

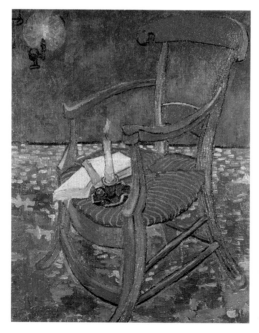

Vincent van Gogh
Gauguin's Chair, 1888
Oil on canvas.
90 × 72 cm (35⅝ × 28½ in)
Van Gogh Museum, Amsterdam.

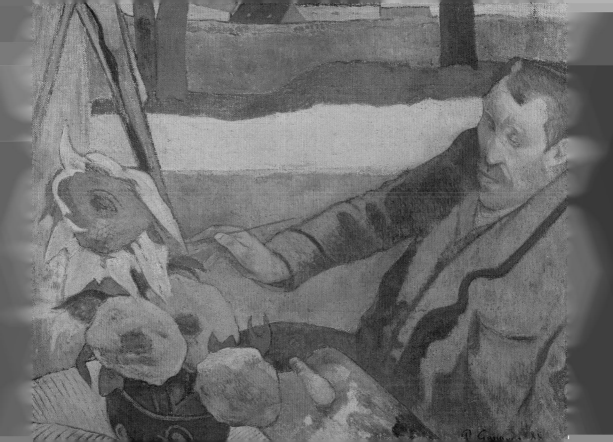

Gauguin returned to Brittany in the spring of 1889. He stayed first in Pont-Aven then moved to the tiny fisherman's village of Le Pouldu. He enjoyed the drama of Le Pouldu's rugged coastline with its famous black rocks - huge granite outcrops that form fantastic shapes above the crashing waves.

Gauguin was joined in Le Pouldu by a small band of loyal disciples. They stayed at the Buvette de la Plage, a small inn whose owner, Marie Henry, was willing to tolerate the odd habits of her artist guests.

The dining-room at Marie Henry's

After the failed utopia of van Gogh's proposed Studio of the South, Gauguin sought to create an alternative artistic community at the Buvette de la Plage. One of the group, the Dutch artist Meyer de Haan, kept the destitute Gauguin afloat by paying his bills.

Marie Henry gave the artists permission to decorate the dining- room of the inn, and soon every surface was covered with imagery. There were scenes of Breton life painted in a style that echoed folk art, to suggest an affiliation between the activity of the artists and what they saw as the primitive power and simplicity of rural rituals. Other images evoked different kinds of primitive: in one panel Gauguin painted a naked, dark-skinned woman (she is surrounded by sunflowers – perhaps a memory of van Gogh) and on a shelf above the fireplace he installed a small statue of an Afro-Caribbean woman from Martinique. The decorative scheme was meant to evoke the idea of a fraternity devoted purely to the ideals of art, free from the pressures of the commercial art world, just as Breton peasants and non-Western peoples lived in harmonious communities free from avarice, or so the artists mistakenly believed. Sérusier, who had joined Gauguin in Le Pouldu, painted onto the wall the composer Richard Wagner's attack on the commercialization of art: 'I believe in a Last Judgement at which all those who, in this world, have dared to adulterate sublime and pure art, all those who have soiled and degraded it by the baseness of their feelings and by their cheap covetousness for material pleasures, will be condemned to terrible sorrows.'

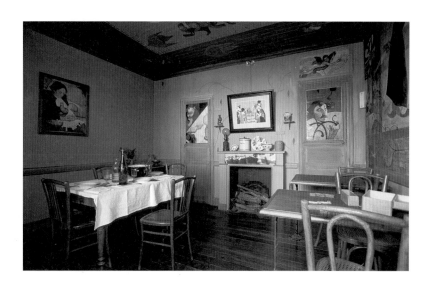

Reconstruction of the dining-room of the Buvette de la Plage.

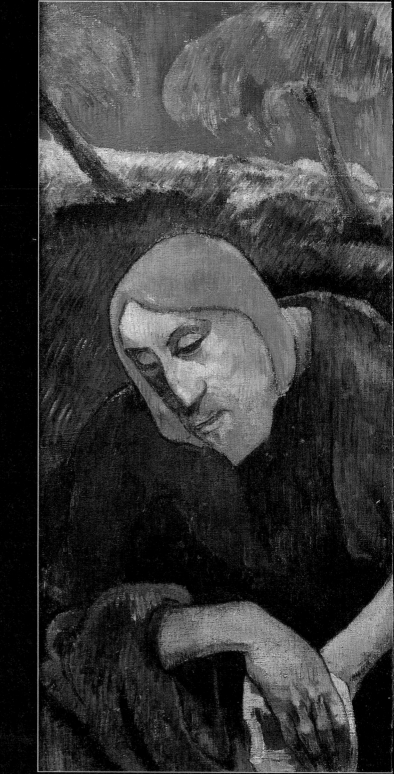

Christ in the Garden of Olives

Paul Gauguin, 1889

Oil on canvas, 72.4 × 91.4 cm (28½ × 36 in)
Norton Museum of Art,
West Palm Beach, Florida

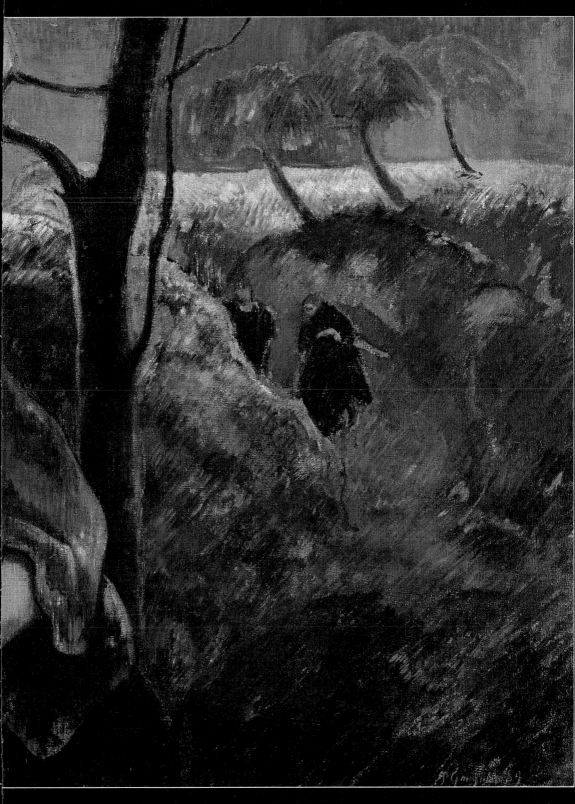

Christ in the Garden of Olives

Gauguin painted *Christ in the Garden of Olives* towards the end of his stay in Le Pouldu. In it he combined his two great innovations of the Breton period: first, the use of distorted forms and non-naturalistic colours to symbolize ideas and emotions; and second, the adoption of religious subject-matter to convey a complex set of personal meanings.

On one level the image is simply a religious painting. The event depicted is found in the Gospels: during the night before his crucifixion, Jesus prays in the garden at the foot of the Mount of Olives in Jerusalem. The sky is light blue, suggesting that dawn is approaching and with it Jesus's final sacrifice. In the background two shadowy figures may be the disciples who slept a short distance from Jesus as he prayed.

On another level the painting is full of personal resonance for Gauguin. Van Gogh had spoken often of the value of religious painting during Gauguin's stay in Arles, and for the most part the Frenchman had been cruelly dismissive of the Dutch painter's words. *Christ in the Garden of Olives* is a belated and perhaps guilt-ridden response to his friend's interests. That van Gogh was on Gauguin's mind as he painted the image is confirmed by the red hair and beard given to Jesus. Gauguin sent van Gogh a letter with a sketch of the painting. Van Gogh, remaining true to his belief that the painter should look closely at the world rather than working from his imagination or memory, was scathing about Gauguin's olive trees, which he said were utterly unconvincing.

If the painting is partly concerned with Gauguin's feelings about van Gogh, it is also very much a self-portrait: the facial features given to Jesus are recognizably Gauguin's own. We see the heavy-lidded eyes and hooked nose for which he was famous, and which he always exaggerated in paintings of himself, such as *Portrait of the Artist with the Yellow Christ*. Gauguin thus shows himself as the tormented saviour, deserted by his disciples just as Jesus would be betrayed by Judas Iscariot's kiss on the morning following the night in the Garden of Olives.

The painting tells us much about how Gauguin saw himself as an artist and about his prickly relations with his own disciples. As a Symbolist, Gauguin was inclined to see himself as a gifted seer, a man unlike others, possessed of inner visions and a profound

knowledge of the mystery of the world. He was also keenly aware that, despite the support of a few loyal friends, he was still unable to sell his work. To picture himself as Jesus was a good way to express the idea that he was a misunderstood genius, an exceptional being who was doomed to suffer at the hands of those who could not hear his message. He was also inclined to quarrel with those around him and to jealously guard what he saw as his artistic innovations. He was increasingly suspicious of Bernard, whom he feared might be less a disciple than a rival, and he felt let down by old friends in Paris who refused to support him financially. The dark figures lurking behind Jesus/Gauguin suggest the artist's paranoid fear that those closest to him might not be reliable.

Gauguin wearing a Breton cardigan in Copenhagen, c.1891.

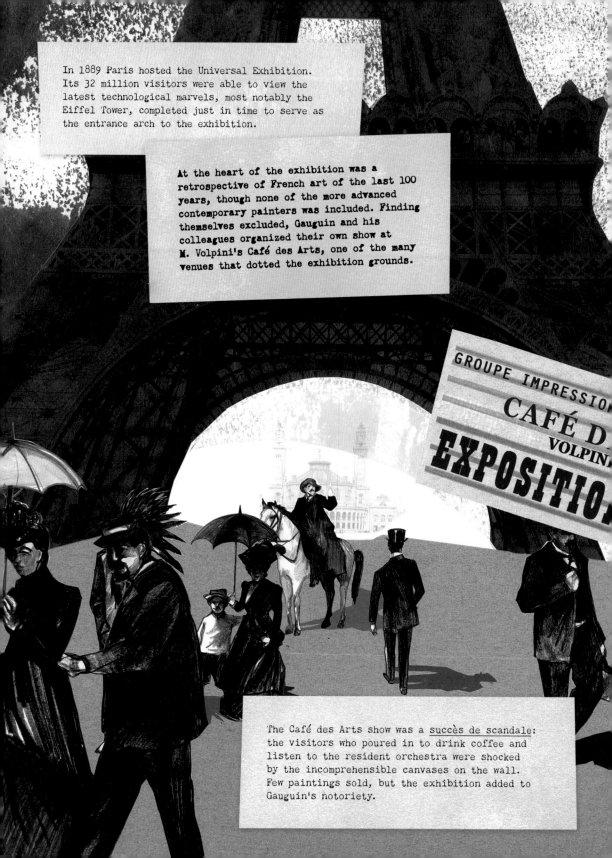

In 1889 Paris hosted the Universal Exhibition. Its 32 million visitors were able to view the latest technological marvels, most notably the Eiffel Tower, completed just in time to serve as the entrance arch to the exhibition.

At the heart of the exhibition was a retrospective of French art of the last 100 years, though none of the more advanced contemporary painters was included. Finding themselves excluded, Gauguin and his colleagues organized their own show at M. Volpini's Café des Arts, one of the many venues that dotted the exhibition grounds.

GROUPE IMPRESSIO[N]
CAFÉ D[E]
VOLPIN[I]
EXPOSITIO[N]

The Café des Arts show was a succès de scandale: the visitors who poured in to drink coffee and listen to the resident orchestra were shocked by the incomprehensible canvases on the wall. Few paintings sold, but the exhibition added to Gauguin's notoriety.

Dreaming of the tropics

As well as scientific sensations, the Universal Exhibition also included crowd-pleasing displays. Visitors lined up to see the world's biggest diamond and a spectacular Wild West performance by Buffalo Bill and Annie Oakley, who brought with them a herd of wild horses and a troupe of Native Americans.

Gauguin was fascinated by the pavilions that displayed the peoples and cultures of France's colonial holdings. He examined the art and architecture from Madagascar and spent much time in the replica of a Javanese village, where he was captivated by the unfamiliar movements of the female dancers. He also bought a series of photographs of the Buddhist temple of Borobudur in central Java. Later he would use these photographs as the basis for some of his most important paintings.

Watching the dancers at the exhibition awakened in Gauguin a renewed desire to travel to the tropics. He thought at first of travelling to Madagascar and tried, in vain, to persuade Bernard to accompany him: the island, he wrote, offers many 'attractions by way of types, mysticism and symbolism. There you have Indians from Calcutta, tribes of black Arabs and the Hovas, a Polynesian type.' Gauguin never went to Madagascar, but he was now fixed on the idea of a voyage to distant lands. Within two years he would leave for Tahiti.

Relief from the ninth century Buddhist temple, Borobudur, Java.
Photograph formerly in Gauguin's collection.
24 × 30 cm (9½ × 11¾ in)
Musée de Tahiti et des îles.

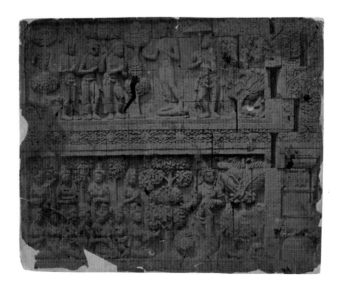

Soyez amoureuses vous serez heureuses

Gauguin carved *Soyez amoureuses vous serez heureuses* after
visiting the Universal Exhibition. The main female figure, whose
body Gauguin darkened with brown dye, recalls the dancers and
other colonized peoples that he had seen at the exhibition. Other
elements in the image are harder to identify. The fox-like animal
may be an avatar of the artist – at times he referred to himself as
a cunning fox – and the odd figure above, a woman with head
in hands that recalls the pose of a Peruvian mummy Gauguin
had seen at the ethnographic museum at the Trocadéro in Paris,
may refer to his childhood in Lima. In the upper right corner a
male figure looks down enigmatically, his thumb in his mouth in
a cryptic gesture. Other strange figures and odd faces that peer
from half-hidden vantage-points add to the general confusion of
the image. In good Symbolist fashion Gauguin hints at various
possibilities without making anything clear. The panel's densely
layered meanings lend a feeling of deep mystery to the image, a
sense that profound truths are being revealed here without being
explicitly stated.

What Gauguin's attitude was to the performers he saw at the
exhibition has been much debated. Some have argued that
he was a typical French male, enjoying the spectacle of foreign
bodies. Others have suggested that he was sympathetic to the
plight of the performers, often brought to Europe against their
will and put on show like animals in a zoo. *Soyez amoureuses vous
serez heureuses* does nothing to resolve the question. Perhaps
the main woman is trapped, like the performers on display at the
exhibition. Perhaps the hand that reaches down to grasp hers –
the artist's own hand? – will lift her up to save her? Or is
Gauguin the male figure, leering at the woman, his thumb an
obscene gesture?

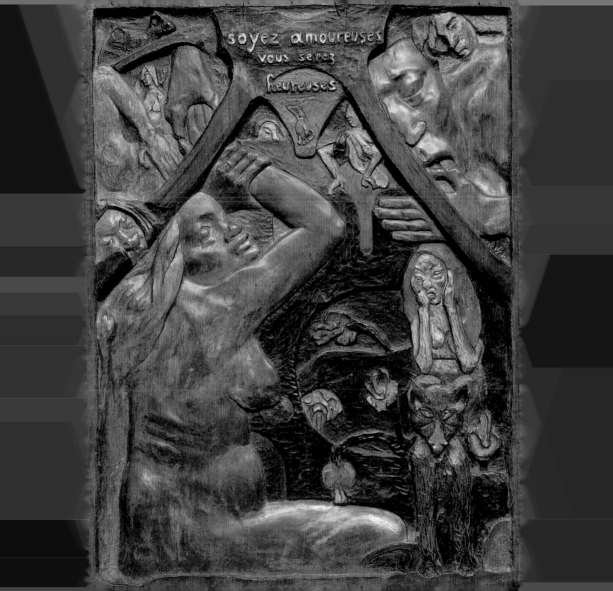

In 1891 Gauguin held a large sale of his work.
For once he was successful, and with the money he
raised he was able to realize his dream of sailing
for the South Pacific. His friends saw him off with
an elaborate banquet in his honour. Mette was less
impressed. He was, she wrote, a selfish monster.

The voyage from Marseilles to Tahiti
took two months. Gauguin had a
second-class ticket but his previous
experience as a sailor allowed him
to befriend the ship's officers and
he spent most of his time in the
relative comfort of their quarters at
the stern of the ship.

What Gauguin hoped to find in Tahiti is clear from a letter written to Mette: 'May the day come - and perhaps soon - when I can flee to the woods on a South Sea island, and live there in ecstasy, in peace and for art. With a new family, far from this European struggle for money.' The reference to a new family was designed to hurt his estranged wife.

Ever since Europeans had first arrived in Tahiti they had seen it as a terrestrial paradise. After long voyages across the endless ocean, sailors fell instantly in love with the island's balmy climate and fecund vegetation.

In the journal he kept, Gauguin described his burning desire to set foot on the promised land and his excitement at seeing the island for the first time. His ship arrived at night. Against a dark sky he saw the jagged contours of a mountain rising above the horizon. It looked, he wrote, like the first dry land emerging after the Flood, a refuge to which a solitary family had clung. The biblical reference makes clear that Gauguin thought of Tahiti as a kind of Eden.

Paradise lost

When he disembarked in Papeete, Tahiti's capital, Gauguin was sorely disappointed. Instead of an unspoilt Garden of Eden he found a typical French colony: newly built European-style architecture, colonial officials imposing their rules and regulations on the native population, and Protestant and Catholic missionaries doing their best to persuade the Tahitians to give up their former beliefs in favour of Christianity. 'Tahiti', the artist lamented, 'is gradually becoming French and the old life will slowly disappear.' Where Gauguin had hoped to find savages he had found 'a European way of life aggravated by colonial snobbery and an imitation, grotesque to the point of caricature, of our customs, manners, vices and civilized absurdities'. He gloomily pasted into his journal a photograph of the Tahitian king in European military uniform.

The Tahitians found the artist, with his strange clothes and long hair, an entertaining figure. The colonial authorities were less amused: the French governor suspected that he was not an artist but a spy sent by the government at home to keep an eye on him.

Savage traces

Despite his disappointment, Gauguin believed that underneath their recently adopted European manners and clothing the Tahitians retained aspects of their true nature – what he described as an instinctive animal grace and a passion that could be seen burning deep in their eyes. He was attracted to the graceful beauty of Tahitian women but at the same time frightened by what he imagined to be their cannibalistic instincts. In his journal he recounted a probably invented event: his encounter with a princess of the Tahitian court in Papeete. When she first entered his room he thought she looked like a ferocious animal, her 'cannibal' jaws ready to rip and tear. After sharing with her a bottle of absinthe he found his attitude changing: now he could see her sensual beauty. In his view of Tahitian women, Gauguin was typical of many European visitors who mistakenly believed the myths about Polynesia – both good and bad – that for more than a century had been repeated by Westerners.

Into the jungle

Where Gauguin was different from many of his fellow European voyagers was in his desire to get as close as possible to Tahiti and its culture. His fervent desire was to shed his civilized ways and finally to become what he had long claimed to be: a savage. To this end he left Papeete in search of a pure and unspoilt Tahiti, renting a wooden hut in the small village of Mataiea on Tahiti's southern coast. From his hut Gauguin looked out over a blue lagoon to the coral reef and the vast ocean beyond. To the east he could see the far end of the island and the steep slopes of Mount Rooniu. Around the hut were coconut palms, breadfruit trees and huge ferns. Gauguin sat watching the local men fishing and the women arranging the nets on the shore.

Although he was happy, Gauguin quickly realized that life was not as simple as he had imagined. Before his departure he had written to a Danish painter friend, J. F. Willumsen, that 'beneath a winterless sky, on marvellously fertile soil, the Tahitian need only lift up his arms to pick his food; thus, he never works'. In fact, Gauguin found himself unable to fend for himself. He could not fish, and the crops grown in the area belonged to local farmers. Luckily the villagers took pity on Gauguin and gave him gifts of food. Gauguin wrote to Mette about the kindness of the Tahitians, noting that although they were called 'savages' their hospitality made them more civilized than Europeans.

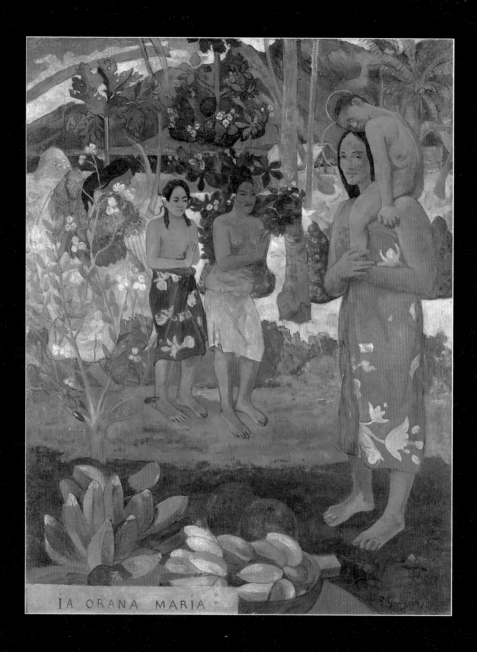

Ia Orana Maria
(Hail Mary)
Paul Gauguin, 1891

Oil on canvas
113.7 × 87.6 cm (44¾ × 34½ in)
The Metropolitan Museum of Art, New York
Bequest of Sam A. Lewisohn, 1951. Acc.n.: 51.112.2

Ia Orana Maria

In *Ia Orana Maria* Gauguin crafted an image of Tahiti as paradise. Underneath the radiant blue of the southern sky a verdant nature runs riot, and in the foreground we see lush mangoes and plentiful breadfruit. Gauguin places at the heart of this Edenic scene an idealized woman and child accompanied by two further women. The woman's noble face and strong limbs correspond to what Gauguin described as the natural beauty of the islanders, where he saw less difference between the sexes than in Europe. He contrasted the vigour of female Polynesians with the degeneracy of French women whose bodies, constrained by corsets, were pale and weak. The bright colours of the *pareo* – the traditional Polynesian robes that the women wear – and of the fruit and vegetation convey Gauguin's sense that Tahiti was a place of luxurious and sensuous warmth.

To show that he was becoming one with Tahitian culture, Gauguin wrote the title of the painting on the surface in Tahitian. The title, which translates as 'Hail Mary' or 'We Greet Thee Mary', indicates that this is not merely a picture of an idyllic island. The mother and child recall European images of Mary and Jesus, and upon closer inspection we see that the two women in attendance are accompanied by an angel half-hidden in the bush to the left. Perhaps Gauguin was suggesting that Tahiti has a purity like that of the Bible figures, a purity that Europe had lost. Or perhaps he was acknowledging that even in Mataiea the locals had been converted by Christian missionaries.

In composing the painting, Gauguin made use of one of the photographs of Borobudur that he purchased at the Universal Exhibition: the two women are based on the figures of the Buddha's devotees. Gauguin brought with him to Tahiti a trunk full of such images and often made use of them in his work. He called these source images his 'friends'.

Gauguin's women

Gauguin was as entranced by Tahiti's women as he was by its landscape, and during his time there he seems to have given shamefully little thought to Mette. When he arrived in Papeete he took as his first lover Titi, but he was disappointed to find that she was only half Tahitian – her father was English. He also found her spoiled by life in the capital, too interested in Western clothes and habits for his taste. When he departed for Mataiea he left her behind as she did not correspond to his ideal image of a Polynesian untainted by civilization.

In Mataiea, Gauguin made great efforts to persuade a young woman from the village to pose for him. At first she resisted: not surprisingly she was wary of this strange figure from overseas. But eventually she agreed, and Gauguin hurried to sketch her before she changed her mind. He described her as he described many Tahitians: not good-looking by European norms, but beautiful nevertheless. He described her mouth as a single mobile line in which was mingled all joy and all suffering.

While in Gauguin's hut the young woman saw a photograph of the famous painting by Manet, *Olympia*, pinned to the wall. 'Is that your wife?' she asked. Gauguin amused himself by answering 'yes'. The young woman declared that she was beautiful. Recalling that Manet's painting had been seen by most French critics as shockingly ugly, Gauguin wrote that the young woman's response showed that Tahitians had an instinctive appreciation of true beauty that many Europeans had lost.

Teha'amana

Although entranced by the natural beauty of Mataiea, Gauguin found himself unable to work due to intense feelings of loneliness. He therefore went in search of a new lover. Riding on a borrowed horse along the coast he was invited to share a meal in a small village. A woman there offered him her daughter, Teha'amana, and Gauguin accepted. Teha'amana was shockingly young – only 13 or 14 years old – but, in his Tahitian journal, Gauguin tried to justify his relationship with her by arguing that this was the local custom. What his Danish wife thought about the arrangement, which he hinted at in his letters, is not recorded.

Gauguin was fascinated by Teha'amana. Her frequent silences he took as evidence of a profound innate wisdom. It seems equally likely that her silence reflected the fact that she had little to say to the French artist into whose home she had been thrust, but Gauguin found only mystery in his young companion. Looking into her dark eyes and finding himself unable to read her thoughts, he imagined he saw there both an animal innocence and a savage melancholy.

The strange allure of Teha'amana's exotic otherness was heightened by the fact that she had seven toes on her left foot. With Teha'amana at his side Gauguin felt he was becoming one with his adopted culture. 'Bit by bit civilization is leaving me. I'm beginning to think simply . . . I live a free life, enjoying animal and human pleasures.' Gauguin would paint for hours on end with Teha'amana sitting in silence beside him.

Gauguin was entranced by the deep silence of the
Tahitian night. 'The silence of the night in Tahiti
is the strangest thing of all,' he wrote to Mette.
'It only exists here, without even the cry of a bird
to disturb one's rest. Here and there a big dry leaf
falls but doesn't suggest the idea of sound - it is
more like the slight touch of a spirit. The islanders
often walk at night, but silently, with bare feet.'

Gauguin believed that Tahiti
revealed its deepest mysteries
during the hours of darkness.
In his journal he recorded
imagined night-time encounters
with the spirits and deities of
the South Pacific.

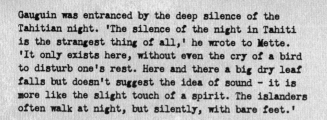

At Mount Aoraï Gauguin hoped to
witness the phosphorescent lights
that, according to local belief, were
the ancestral spirits who visited
the living when darkness fell. In
the pitch black of the night Gauguin
saw a powdery luminosity close to
his head, but he wrote that this was
simply the glow released by a fungus
on the dead wood from which he had
made his fire.

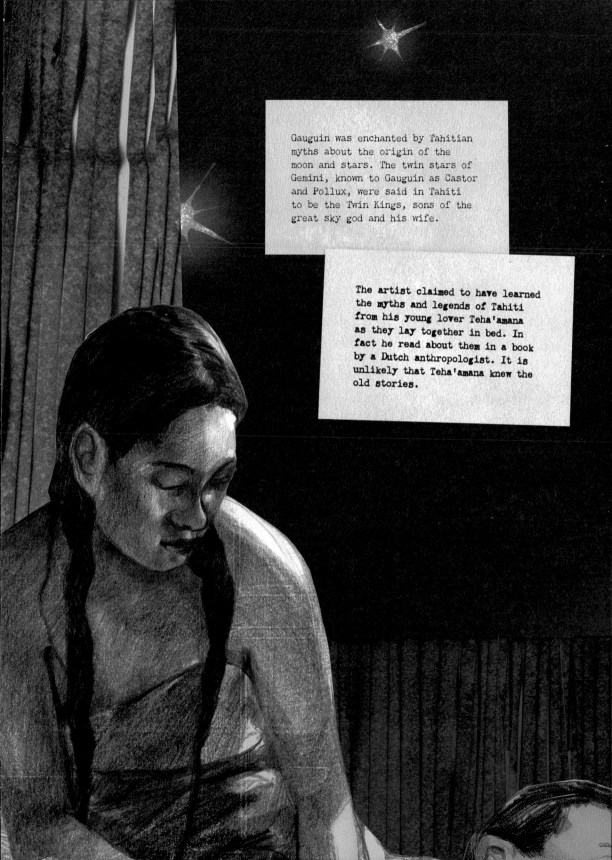

Gauguin was enchanted by Tahitian
myths about the origin of the
moon and stars. The twin stars of
Gemini, known to Gauguin as Castor
and Pollux, were said in Tahiti
to be the Twin Kings, sons of the
great sky god and his wife.

The artist claimed to have learned
the myths and legends of Tahiti
from his young lover Teha'amana
as they lay together in bed. In
fact he read about them in a book
by a Dutch anthropologist. It is
unlikely that Teha'amana knew the
old stories.

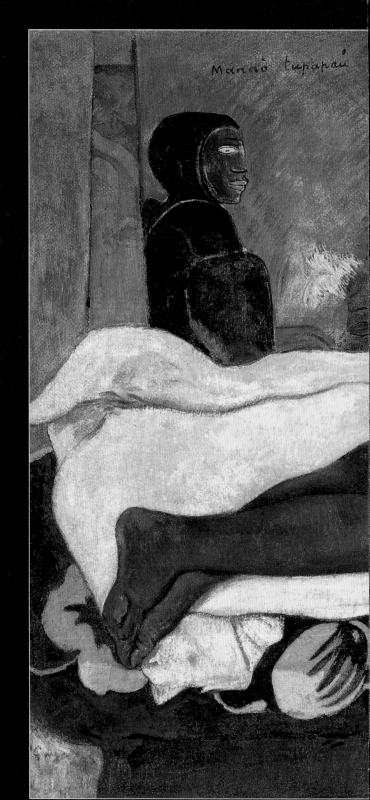

Manao tupapau
(The Spirit of the Dead Watching)
Paul Gauguin, 1892

Oil on burlap mounted on canvas
116 × 134.6 cm (45⅝ × 53 in)
Albright-Knox Art Gallery, Buffalo, NY
A. Conger Goodyear Collection, 1965

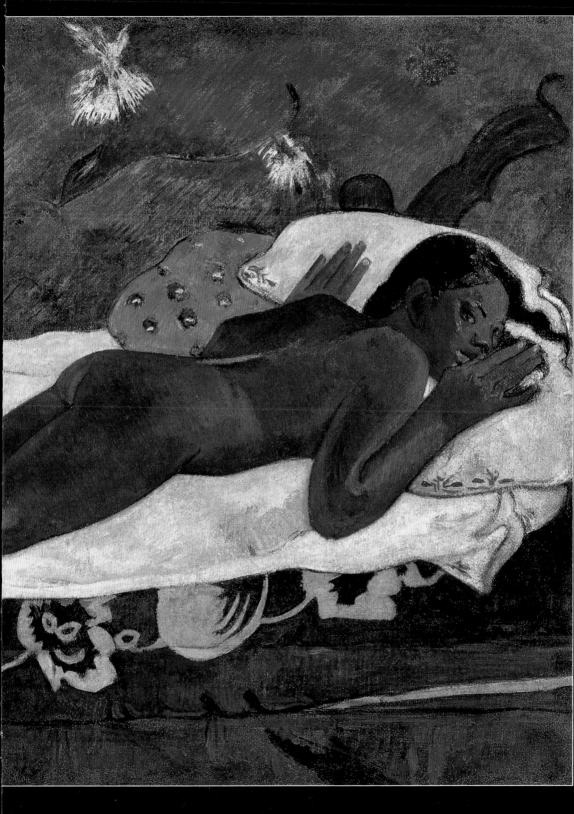

Manao tupapau

One night Gauguin returned from a visit to town to find his rural house in darkness. Trembling with a sudden feeling of apprehension, he struck a match and saw Teha'amana (whom he called Tehura in his journal) lying terrified on the bed. Here is how he described the scene: 'Tehura, immobile, naked, lying face downward flat on the bed, her eyes inordinately large with fear. She looked at me, and seemed not to recognize me. As for myself I stood for some moments strangely uncertain. A contagion emanated from the terror of Tehura. I had the illusion that a phosphorescent light was streaming from her staring eyes. Never had I seen her so beautiful, so tremulously beautiful. . . . I was afraid to make any movement that might increase the child's paroxysm of fright. How could I know what at that moment I might seem to her? Might she not with my frightened face take me for one of the demons and spectres, one of the Tupapaus, with which the legends of her race people sleepless nights?'

Gauguin seems to have been indecently aroused by the girl's fear and in his painting of the scene *Manao tupapau,* he takes great pleasure in depicting her vulnerable young body, placing it prominently in the centre of the image. But he also tries to

empathize with her, imagining how she herself might see him. Gauguin wants us to imagine that he is not a detached observer but a participant in the Tahitian experience. He senses, as does Teha'amana, the presence of the *tupapau*, which he shows to the left alongside the carved bedpost. The painting's avoidance of perspective implies a minimal distance between the artist and what he depicts, while its simplified form and colour allow Gauguin to suggest that he has shed his civilized ways, that he has become, like the Tahitian, a 'primitive'.

Although Christian missionaries had eradicated much of the native Tahitian belief system, the fear of *tupapaus* had survived. Unlike much of what he knew about Polynesian mythology, learnt not as he claimed from Teha'amana but from a book, it is likely that Gauguin had spoken to his young lover about the spirits that haunted the night. To capture the sense of trepidation as Teha'amana waits in the darkness, Gauguin used gloomy colours. 'The harmony', he wrote, 'is sombre and frightening, tolling in the eye like a funerary knell.' On the back wall we see flashes of light representing the night-time phosphorescence Gauguin had himself seen on his journey to Mount Aoraï, the sacred mountain at the heart of Tahiti.

Gauguin was eager to immerse himself in Tahitian life, but he did not forget that the real audience for his paintings was not in Polynesia but in Europe. Along with other paintings, he sent *Manao tupapau* back to Paris to be exhibited. He also arranged for it to be shown in Copenhagen, where Mette, despite their failed marriage, continued to organize exhibitions of his works and to lay claim to any money they might raise. Perhaps worried that Mette and her family would see the painting as evidence of his infidelity, Gauguin told her a rather different story about the painting's genesis to that recorded in his journal. It was, he said, not an indecent picture, but merely a study of a nude and a symbolic contrast between Life, embodied by the young girl, and Death, represented by the *tupapau*.

Idol with a Pearl
Paul Gauguin, late 1892 – early 1893

Polychromed tamanu wood,
pearl, gold chain necklace
23.7 × 12.6 cm (9⅜ × 5 in)
Musée d'Orsay, Paris

Becoming a savage

When Gauguin described Tahitians as savages this was meant as a compliment. He saw himself as a savage, too, because of his Peruvian blood. His desire was to become more purely savage, to shed his European ways.

In Mataiea he became friends with a young man called Totefa, who would watch in fascination as he worked. In his journal Gauguin recorded how one day he put a hammer and chisel and a piece of wood in Totefa's hands. He wanted him to try to carve. Totefa returned the tools to Gauguin saying that the artist was a man unlike others, that he alone was capable of making art, and that he was 'useful to others'. Gauguin was greatly touched by these words, so different from Mette's accusations that he was selfishly wasting his time when he should be supporting his family. Gauguin wrote that Totefa's words were those of a savage or a child, for only such simple beings instinctively understand the true value of art. European adults, he believed, were too concerned with practical questions and with money.

When Gauguin needed more wood for carving, Totefa took him on an arduous trek into the mountains in search of an ironwood tree. As Gauguin chopped unrestrainedly into the tree, he felt himself becoming a primitive: 'I struck with rage and, hands blood-covered, I chopped with the pleasure of a gratified brutality. . . . My old reserves of civilization were thoroughly destroyed. I returned at peace, sensing myself from now on a different man, a Maorie.'

Idol with a Pearl

The wooden sculptures that Gauguin made in Mataiea are deliberately crude in technique. Their roughly worked surface and simple forms are the sign that the artist has shed his European training, that he is now working instinctively and unrestrainedly, like a savage. *Idol with a Pearl* nevertheless retains Gauguin's earlier interest in Symbolist mystery. An enigmatic figure spies on the impassive idol from behind, suggesting a secretive and shadowy narrative. Like much of Gauguin's work in Tahiti it is a hybrid creation, part European, part Polynesian. This was true of Gauguin too. He immersed himself in Tahitian life, wishing fervently to become like the island's native inhabitants, but he could never forget that he was a European. Nor could he ever forget the Paris art world, which he still dreamed of conquering one day.

A vanished culture

Gauguin was aware that Tahiti had changed greatly since the arrival of Europeans and dreamt of witnessing how it used to be. In his journal he described a journey to a remote valley where he had a vision of the past returned to life: 'Before me I can clearly see the statues of their divinities, though actually they have long since disappeared; especially the statue of Hina, and the feasts in honour of the moon-goddess.' He even imagined hearing the sounds of the past: 'Around her they dance according to ancient rite, the *matamua*, and the *vivo* [a Polynesian reed-pipe] varies its note from lightness and gaiety to sombreness and melancholy according to the colour of the hour.' Gauguin often thought of Tahiti as being split between gaiety and melancholy: was the island a place of joyous and luxuriant fertility, a tropical paradise, or was it a place of silence, of isolated solitude at the edge of the endless ocean, a place where the local culture was dying and old religious sites lay deserted and in ruins? Because most of the old statues had vanished, in his paintings Gauguin drew on a range of non-Western sources – Buddhist, Japanese, ancient Egyptian – to forge an invented picture of what Tahitian ritual art might have looked like.

The Tahitian spirit world

As well as imagining that he saw long-gone statues, Gauguin claimed to have seen Tahitian spirits. On another journey into the island's interior he described coming upon a young woman at a turn in the path. After pouring water between her breasts, she sensed his silent presence and disappeared into the water below where she transformed into an eel. The veracity of this account is called into question by the fact that Gauguin's painting of his encounter with this mysterious being is based on a photograph that he had purchased from a French photographer. It shows a boy drinking from a spring in Samoa.

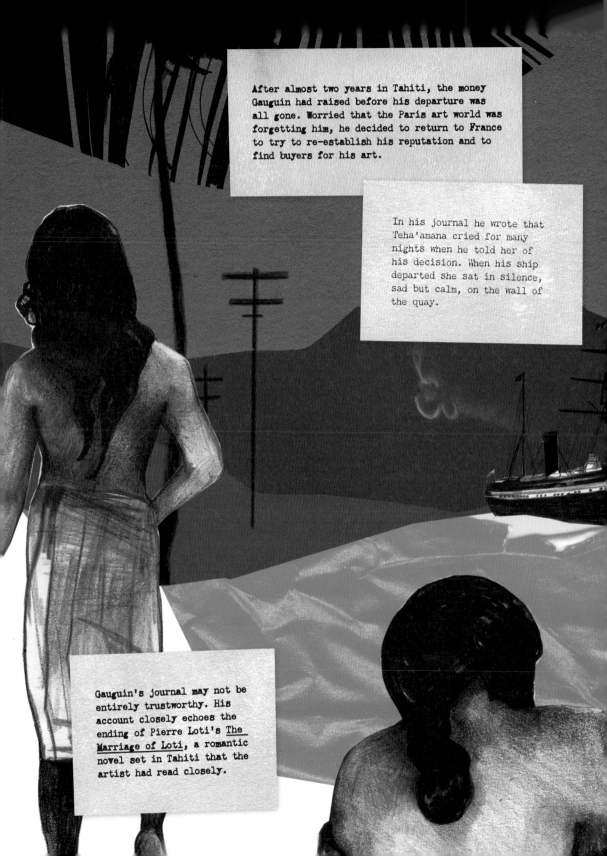

After almost two years in Tahiti, the money Gauguin had raised before his departure was all gone. Worried that the Paris art world was forgetting him, he decided to return to France to try to re-establish his reputation and to find buyers for his art.

In his journal he wrote that Teha'amana cried for many nights when he told her of his decision. When his ship departed she sat in silence, sad but calm, on the wall of the quay.

Gauguin's journal may not be entirely trustworthy. His account closely echoes the ending of Pierre Loti's The Marriage of Loti, a romantic novel set in Tahiti that the artist had read closely.

Old friends

When he arrived back in Paris in the later summer of 1893,
Gauguin was reunited with some of his old friends. After the
silence of Tahiti he enjoyed the banter of the cafés and studios.
He often welcomed guests to his studio, where he would entertain
them by telling stories about his time in the South Seas or by
fooling around on the harmonium.

Noa Noa

Gauguin found it hard to re-establish himself as an important
artist. During his two years in Polynesia other painters had caught
the eye of the critics. He tried in vain to interest the Paris art world
in his work by organizing an exhibition at an important gallery
and another in his studio. For the studio show he created a series
of ten woodcut prints to accompany an edited version of his
Tahitian journal. He hoped that the journal would help to explain
his Tahitian paintings to the critics, but unfortunately the text was
not finished in time. The woodcuts, however, were a powerful
record of his interests. They are roughly carved in order to
suggest the artist's savage nature. The frontispiece shows figures
around a central tree. The two smaller figures are a Tahitian
Adam and Eve, at rest beneath the Tree of Knowledge. The larger
figures show Tahiti after its loss of innocence, which Gauguin
blamed on the arrival of the Europeans. Now the Garden of Eden
is spoiled and the Tahitians must labour.

Gauguin playing the
harmonium, 1895.
Photograph by Alphonse Mucha.
Private collection.

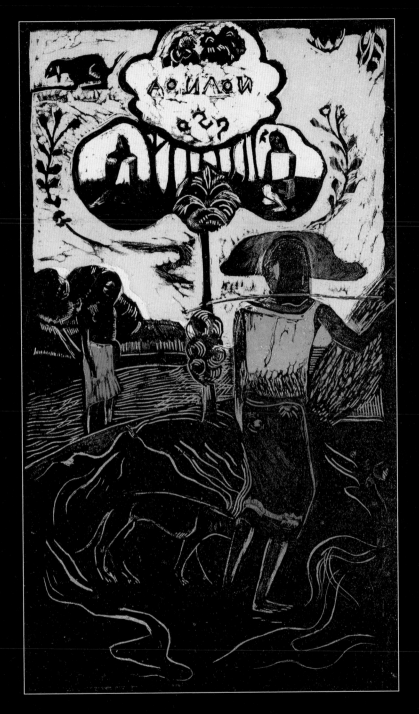

Noa Noa (Fragrant Scent)
Paul Gauguin, 1893–94

Woodcut
35.7 × 20.5 cm (14 × 8 in)
Private collection

Breton interlude

Gauguin sold little in Paris and received little critical attention beyond a few articles written by loyal friends. Disheartened by his failure to recapture his former prominence and once again short of money, he retreated to Brittany in the hope of reviving the Pont-Aven School. He took with him a young woman called Annah, described by the artist as Javanese but more likely Sri Lankan.

Sadly Gauguin found no more success in Brittany than in Paris. He was unable to reassemble an admiring circle of disciples, for the old friends from the Pont-Aven days had either dispersed or – in Bernard's case – become significant artists themselves. Gauguin became obsessed with the idea that Bernard had stolen his ideas and was presenting them to the critics as his own. There were some grounds for Gauguin's suspicion: Bernard was actively promoting the idea that he, and not Gauguin, had been the real innovator in Pont-Aven.

Dismayed by the break-up of his band of followers, Gauguin found little solace in Brittany. He was no closer to finding what he had long desired: a real sense of connection with the native inhabitants of the region. Indeed, at times they manifested extreme hostility towards this strange artist. In the town of Concarneau, famous for its fishing-fleet and for the sardine factories that still line the quayside today, Gauguin was attacked by a group of Breton sailors who had insulted Annah and the pet monkey that always accompanied her. In the scuffle the artist's ankle was badly broken, and he was confined to bed for four months. To add insult to injury, while he was immobilized Annah returned to Paris and stole everything of value from his studio.

This was the final straw. Gauguin's return to France had ended in ignominy and he had found few allies and fewer buyers. Convinced that there was no future for him in Europe, he made the fateful decision to return to Polynesia, and in the summer of 1895 left his country of birth for the last time.

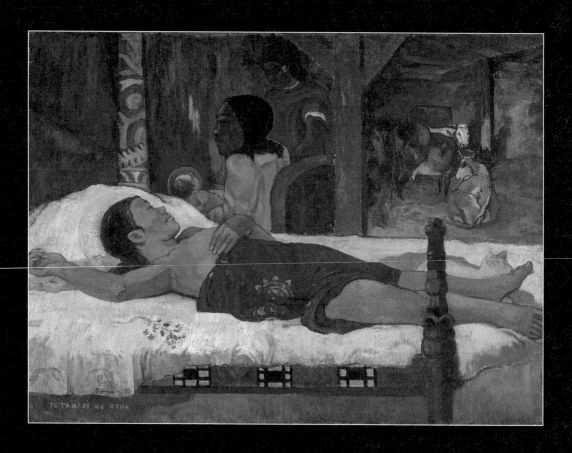

Te tamari no atua
(The Birth)
Paul Gauguin, 1896

Oil on canvas, 96 × 131.1 cm (37 ¾ × 51⅝ in)
Neue Pinakothek, Munich

The return to Tahiti

Gauguin arrived back in Tahiti full of renewed optimism.
He rented a small plot of land in Punaauia, a few miles outside
Papeete. There he built a hut with a small bedroom and a large
sunlit studio. Teha'amana, he discovered, was now married, but
he soon found another shamefully young lover, the 14-year-old
Pahura. She would bear him two children. The first, a girl, died
when just a few days old. The second, a boy named Émile, would
live a long life: 80 years later he was still entertaining visitors to
Tahiti with stories about his father.

When his first child with Pahura was born, Gauguin painted *Te
tamari no atua*. The painting transposes the biblical story of the
birth of Jesus to Polynesia, with Mary given the features of Pahura
and the baby Jesus attended by two Tahitian women. The painting
echoes the composition of *Manao tupapau*, but the earlier image's
sense of dark foreboding has been replaced by the joy of new life.
By presenting the birth of his own child in the guise of the Nativity,
Gauguin implies that he himself is an artist whose creative power
equals that of God.

Gauguin's house in Tahiti, c.1895.
Photograph by Jules Agostini
Musée du Quai Branly, Paris.

Illness and depression

Shortly before he left France, Gauguin had become infected with syphilis by a prostitute. The devastating illness, for which there was no effective cure before the invention of antibiotics, gradually took hold of his body. Open sores began to appear on his legs and he was troubled by intense pains in his ankle, which had never fully healed following the injury in Concarneau. For days at a time he was bed-ridden. To make matters worse he was rapidly running out of money. To survive he took employment for a time with the hated colonial administration.

These troubles, together with a feeling of total isolation (few of his old friends bothered to write to him), brought Gauguin to the edge of despair. Further bad news arrived in 1897 when a rare letter from Mette informed him of the death of his favourite daughter, Aline, from pneumonia.

Gauguin's darkening mood is apparent in *Self-portrait near Golgotha*. Once again he compares himself to Christ: Golgotha, also known as Calvary, is the hill upon which Jesus was crucified. But now the artist is subdued and impassive, his gaunt features emptied of the energy so evident in earlier self-portraits. Gone too are the radiant colours of his Tahitian paintings. Behind him stands the sombre slope of Golgotha, hemming him in visually as though there is no possibility of escaping from his fate. Alone and ill, Gauguin the creator senses that his final martyrdom is close.

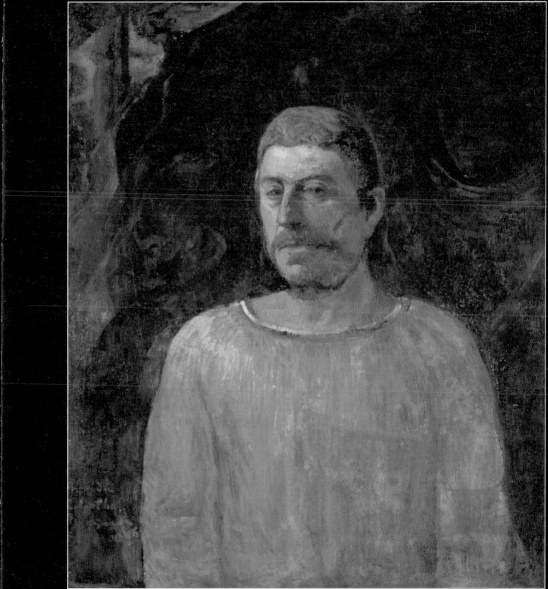

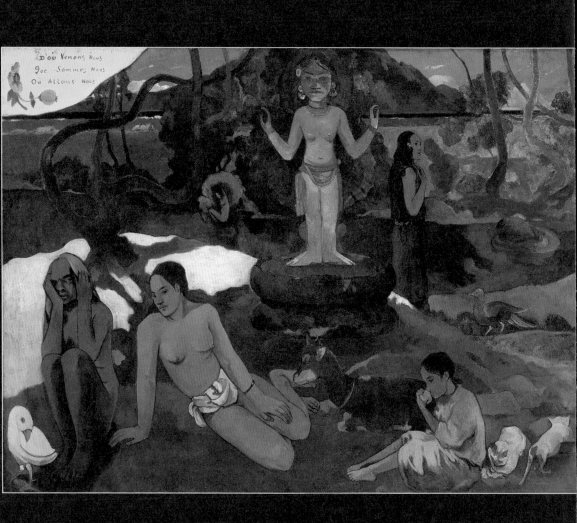

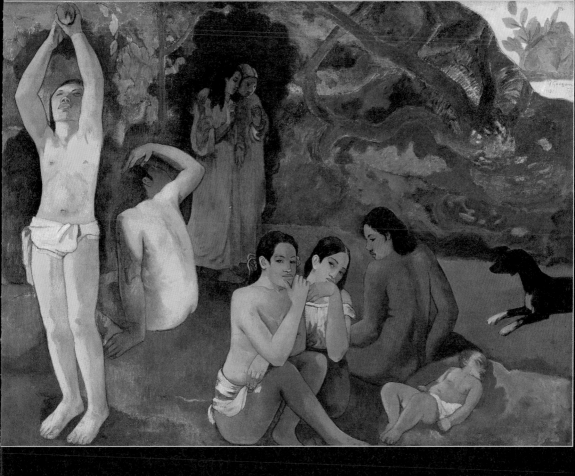

Where Do We Come From?
What Are We? Where Are We Going?
Paul Gauguin, 1897–98

Oil on burlap
139.1 × 374.6 cm (54½ × 147½ in)
Museum of Fine Arts, Boston

Where Do We Come From? What Are We? Where Are We Going?

At the end of 1897, after suffering a series of heart attacks and with his body increasingly ravaged by syphilis, Gauguin went into the mountains and tried to commit suicide by swallowing arsenic. He wanted to die alone in the forest, surrounded by the great trees and by the silence of Tahiti.

Gauguin's suicide attempt failed, and the following morning he dragged himself back to his studio. He wrote a letter to a painter friend in France, Daniel de Monfreid, recounting the failed suicide and describing the great work that he had painted shortly before as his 'testament' painting. This was the enormous *Where Do We Come From? What Are We? Where Are We Going?*, almost four metres across. Remarkably, it was completed in less than a month. Gauguin worked feverishly to get his ideas down on the rough burlap surface before what he believed was his impending demise. 'Before death I put into it all my energy, a passion so painful in circumstances so terrible, and my vision was so clear that all haste of execution vanishes and life surges up.'

The painting is an exploration of the mysteries of human life set against a panoramic Tahitian landscape. In typical Symbolist fashion Gauguin has put together a complex image that alludes to a wide range of meanings without providing a clear narrative. In the lower, right corner a baby symbolizes the beginning of life, while at lower, left the old woman with head in hands (a figure first seen in Gauguin's *Soyez amoureuses vous serez heureuses*) suggests life's termination. Between these two poles Gauguin presents a series of dualities that structure human existence. The barely clothed figure who dominates the centre of the painting and who reaches up to pluck an apple appears as a somewhat masculine Eve. Perhaps she or he represents the carefree innocence that the artist imagined Tahitians enjoyed before Christian missionaries imposed European ideas about sin and shame. Behind this figure a thick-set, seated nude looks at the standing women in pink-purple robes. In contrast to the innocence of the central figure, these two women were described by Gauguin as being more thoughtful, aware of their own existence and pondering its meaning.

Alongside the central contrast of the blissfully unaware and the reflective we find that of the natural world and the spiritual. The idol with arms raised (based once more on Gauguin's Borobudur photographs) represents the realm of mystical and otherworldly beliefs. The child and animals in front of it symbolize the vitality of nature. Both, Gauguin believed, were strongly present in Tahiti. And both, he believed, were crucial for the artist, who must construct his painting out of the concrete facts of the world but who must also gesture towards the deeper and more profound truths of existence.

Gauguin saw this as his greatest work: 'I believe that this canvas not only surpasses all my preceding ones, but that I shall never do anything better – or even like it.' Hoping that it might be recognized as a masterpiece back in Europe, he rolled up the great canvas and sent it to France. When de Monfreid arranged for it to be exhibited in Paris the critics were baffled by the work's complicated Symbolist iconography. Nevertheless they agreed with the artist that it was an important painting, and the influential dealer Ambroise Vollard kept it in his gallery, along with other canvases that the artist had sent from Tahiti. Gauguin's reputation as a leading French painter was re-established, though he would never return to his homeland to enjoy his renewed success.

Colonial politics

In 1899 Gauguin began writing for *Les Guêpes (The Wasps)*, a satirical political newspaper that supported the interests of poor European settlers and frequently insulted the French colonial and religious authorities. Gauguin's articles, illustrated by mocking caricatures of such luminaries as the island's governor, scandalously hinted at corruption and nepotism. He also wrote scathingly about the impact of colonialism on Tahiti, bemoaning the destruction of its traditional ways and calling for a revival of Polynesian culture.

Gauguin also published his own short-lived newspaper, *Le Sourire (The Smile)*. Like *Les Guêpes*, *Le Sourire* consisted, for the most part, of malicious attacks on colonial officials and church leaders – content that almost landed Gauguin in jail. He printed each copy by hand using a machine known as an Edison Mimeograph and created for each issue an illustrated masthead. The imagery he used, most often borrowed from his own paintings and sculptures, was perhaps more suited to the evocation of Symbolist mystery than to the agitational purposes of the newspaper. This probably explains the failure of the project: Gauguin kept up publication for eight months or so, but the journal never succeeded in findin a large readership. It is, however, a telling episode, one that indicates Gauguin's interest in intervening in the politics of Tahiti. As a painter he dreamt of a Polynesian idyll. As a man he took practical steps to try to preserve that idyll against the ravages of colonialism.

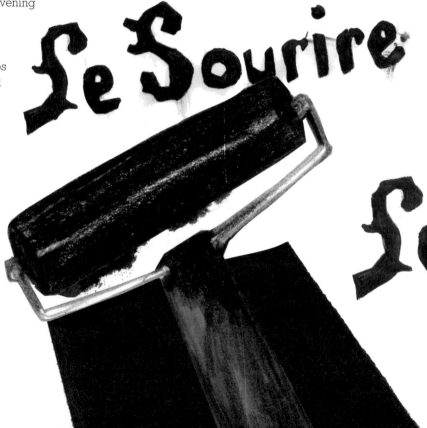

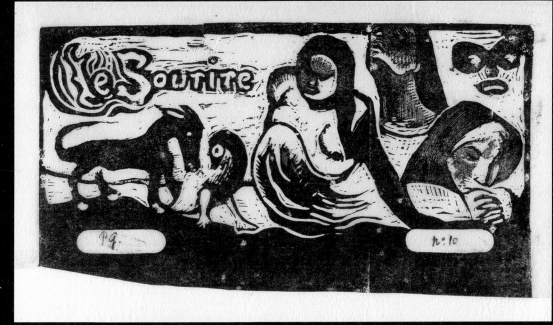

Head Piece for *Le Sourire*
(Three People, a Mask, a Fox and a Bird)
Paul Gauguin, 1899

Woodcut
10.1 × 18.3 cm (4 × 7¼ in)
Art Institute of Chicago. Gift of Edward McCormick Blair 2002.243

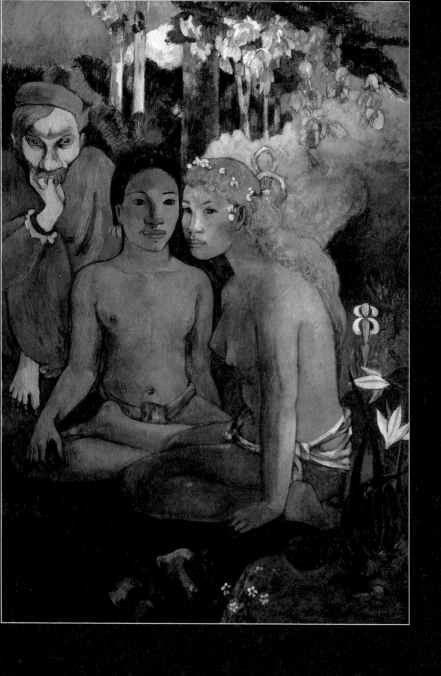

Barbarian Tales
Paul Gauguin, 1902

The Marquesas Islands

In 1901, tired of his brushes with the law and hoping to find at last an unspoilt Polynesian paradise, Gauguin sailed for the Marquesas Islands, a remote archipelago less visited by Europeans than Tahiti. He bought land near the capital Atuona from the local French bishop (having attended mass once or twice to fool the bishop into believing him a respectable man) and built a new home. Decorating the house with carved wooden lintels showing animals and naked women, Gauguin christened it the 'Maison du Jouir'. Its name – meaning 'house of sexual pleasure' – was deliberately provocative. In front of the house he placed a sculpted caricature of the bishop and the nude housemaid with whom the bishop was reputed to have had an affair. He also tried to persuade the locals to remove their daughters from the Catholic school. The authorities responded by charging Gauguin with libel, but he would not live long enough to face trial.

The end approaches

As he lay sick and alone in the Maison du Jouir, Gauguin's thoughts jumped erratically between the present and the past. He remembered with particular fondness his stays in Pont-Aven, creating a number of images of Brittany in the snow (perhaps the thought of the chilly northern French landscape soothed his fever). He also included some of his old friends in paintings of the Marquesas. In *Barbarian Tales* the verdant pleasures of Polynesia, all fragrant flowers and golden bodies, are haunted by the devil-like figure of Meyer de Haan who seems to whisper to them. The innocence of Polynesia, Gauguin's Garden of Eden, is besmirched by the evil influence of Europe.

As death approached Gauguin penned a desolate letter to his friend de Monfreid: 'I only desire silence, silence and again silence. Let me die in peace, forgotten.' On a May morning in 1903 his wish was granted: he succumbed to a heart attack after taking a large dose of morphine. He was buried without fanfare the following afternoon in the Calvary Cemetery above Atuona.

He wanted his grave to be marked not by a headstone but by *Oviri*, a ceramic sculpture that he had created after his first Polynesian voyage. Gauguin had often referred to himself as *oviri*, which in Tahitian means 'wild' or 'savage', so the statue serves as a self-portrait of sorts. Gauguin also knew that in Tahitian mythology *Oviri-moe-aihere*, or 'the savage who sleeps in the wild forest', was one of the deities of death and mourning. The statue was thus a most appropriate marker of his final resting place. The original had been left in France with de Monfreid, but a copy was placed on the artist's grave and remains there to this day.

Gauguin may have wanted to be forgotten but, following his death, his reputation quickly grew. In 1906 *Oviri* occupied pride of place in a large Parisian retrospective of his work. Henri Matisse and Pablo Picasso were both overwhelmed by the power of Gauguin's work, and from that time on his standing as one of the great modern artists was assured.

Oviri
Paul Gauguin, 1894

Stoneware
75 × 19 × 27 cm (29½ × 7½ × 10⅜ in)
Musée d'Orsay, Paris

Bibliography

Bretell, Richard, ed. *The Art of Paul Gauguin*, Art Institute
 of Chicago / National Gallery of Art, 1988.
Hanson, Lawrence and Elisabeth. *The Noble Savage: A Life
 of Paul Gauguin*, Chatto and Windus, 1956.
Maurice Malingue, ed., Henry J. Stenning, trans.
 Paul Gauguin: Letters to his Wife and Friends, MFA
 Publications, 2003 (text first published in 1949 by OH World).
Shackelford, George, ed. *Gauguin Tahiti*, MFA Publications, 2004.
Thomson, Belinda, ed. *Gauguin: Maker of Myth*,
 Tate Publishing, 2010.

George Roddam

George Roddam has taught art history at universities in the
United Kingdom and the United States. His research focuses
primarily on European Modernisms and he has published
numerous articles on the subject. He lives in south-east
England with his wife and two sons.

Sława Harasymovicz

Sława Harasymowicz is a Polish artist based in London.
Her projects include a solo exhibition at The Freud Museum,
London, following the publication of the graphic novel
Sigmund Freud's Wolf Man (2012) and a solo exhibition at The
Ethnographic Museum, Krakow (2014). She has won the Arts
Foundation Fellowship (2008) and Victoria and Albert Museum
Illustration Award (2009).

Picture credits